Sea and Sky
in Watercolour

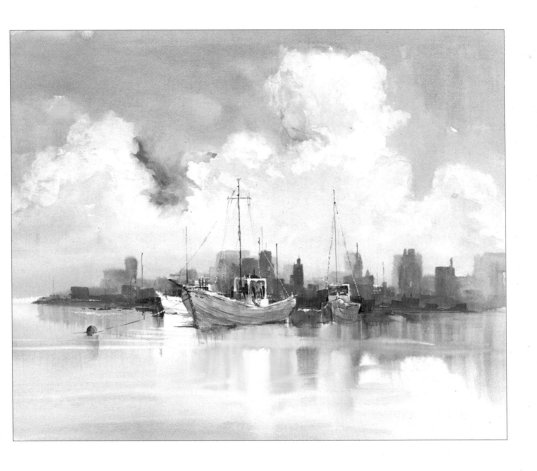

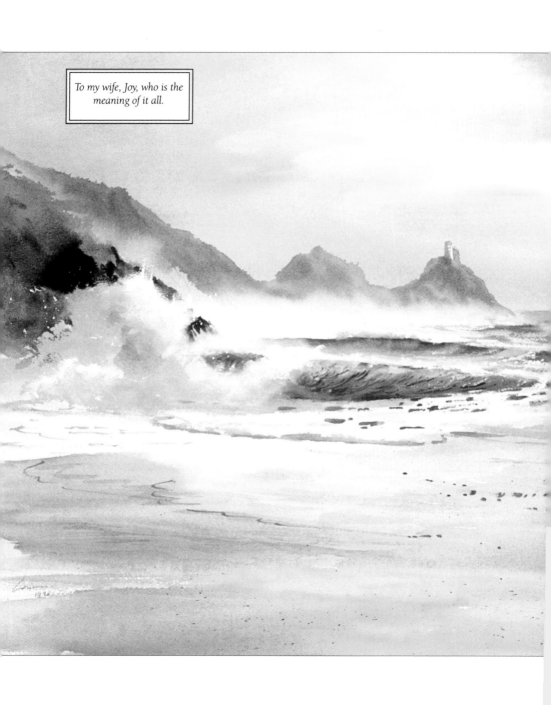

To my wife, Joy, who is the
meaning of it all.

Sea and Sky
in
Watercolour

ARNOLD LOWREY

SEARCH PRESS

This edition first published 2014

Search Press Limited
Wellwood, North Farm Road,
Tunbridge Wells, Kent TN2 3DR

Reprinted 2016, 2018

Originally published in Great Britain 2001

Text copyright © Arnold Lowrey 2001

Photographs by Search Press Studios
Photographs and design copyright © Search Press
Ltd. 2001

ISBN: 978 1 84448 984 8

The Publishers and author can accept no
responsibility for any consequences arising from
the information, advice or instructions given in
this publication.

The publishers and author would like to thank
Winsor & Newton for supplying many of the
materials used in this book.

Suppliers
If you have difficulty in obtaining any of the materials
and equipment mentioned in this book, then please
visit the Search Press website: www.searchpress.com

Publishers' note

All the step-by-step photographs in this book
feature the author, Arnold Lowrey, demonstrating
how to paint sea and sky in watercolour. No
models have been used.

There is reference to sable hair and other
animal hair brushes in this book. It is the
publishers' custom to recommend synthetic
materials as substitutes for animal products
wherever possible. There is now a large number
of brushes available made from artificial fibres
and they are satisfactory substitutes for those
made from natural fibres.

Printed in Malaysia by Times Offset (M) Sdn. Bhd.

I would like to thank Bart O' Farrell,
who got me started;
Skip Lawrence, who made me think
deeply about my intent;
Winsor & Newton, who gave
encouragement;
and John Dalton and Roz Dace of
Search Press, who provided the faith
and opportunity.

Page 1
The Moorings
Size: 520 x 445mm (20½ x 17½in)
The horizontal/vertical structure of this
composition imparts a tranquil mood. Note
how the dark tonal values of the buildings
in the background emphasize the colour and
shapes of the boats

Page 2–3
Mumbles Head, South Wales
Size: 710 x 480mm (28 x 19in)
I used the mingling technique to produce the
variety of soft tones and colours in the sky of
this painting. A clean damp sponge created
the soft edges of the foam in the crashing
waves. The diagonal direction of the main
wave shapes indicates movement. The soft
foreground leads the eye into the painting.

Opposite
Boat in Greek Harbour
Size: 205 x 330mm (8 x 13in)
Colour dominates in this painting, so, to
subdue the effect of light against dark, I
removed virtually every trace of white. I
used the scraper end of my 12mm (½in) flat
nylon brush to create the lighter shapes on
the hull of the boat.

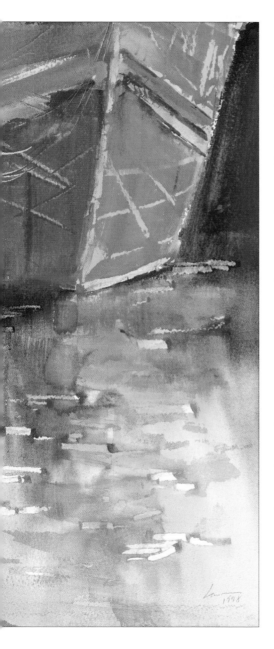

Contents

Introduction

I paint in all media and I am often asked which is my favourite. That is like being asked, 'Who is your favourite child?' I love them all in different ways, but the medium I always come back to is watercolour. It is the one medium where speed has a bearing on the result. It creates a rush of adrenaline, which excites in a way no other medium can. It also lends itself to small parcels of time, and this is convenient for me, as I find that my concentration time span is limited to an hour or two.

In this book I mention some important aspects of painting which were milestones in my life, and which I look back on and say, 'If only someone had told me that, and how important it was'. These include choosing equipment and materials, how to produce clean colour, the control of water, the importance of good shapes and the texture of edges. These are all essential to the understanding of watercolour.

I was trained as an engineer and soon learned the importance of understanding how things work. Success is built on failure; so do not be afraid of making mistakes in the learning process.

Painting with watercolour is not easy. If it were, no one would want to do it! It is certainly not a relaxing or restful occupation. The real reason people want to paint is because it is very interesting! If the subject is interesting to you then there is a good chance it will be interesting to the viewer afterwards. If things go wrong in painting, I always go back to my definition of fine art, which is 'painting shapes in tone and colour with imagination and skill'. Good shapes make great pictures – look at the wonderful shapes made by the group of ballerinas in paintings by Degas.

Get to know the subject before you start painting. Take time to watch the breakers form in the sea; study the foam patterns, note how the waves crash against rocks and how the water pours off them, observe how the sun reflects off the waves. Study the various types of cloud formation – cumulus, cirrus, etc., and the different colours in the sky. Then, you will be able to apply this new-found knowledge with imagination and skill. I hope this book will slay a few dragons for you, and make you try new things – if you are bold enough, you will produce original paintings that will surprise you.

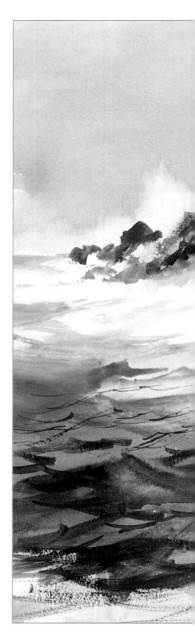

Stormy Seas
Size: 675 x 520mm (26½ x 20½in)
The rough seas pounding the shoreline provides all the action in this composition, so the sky was kept quite simple. The diagonal structures in the sea give a feeling of movement, and this is heightened by the use of soft and rough edges on the waves. The diagonals repeated on the land area adds to the overall dramatic effect.

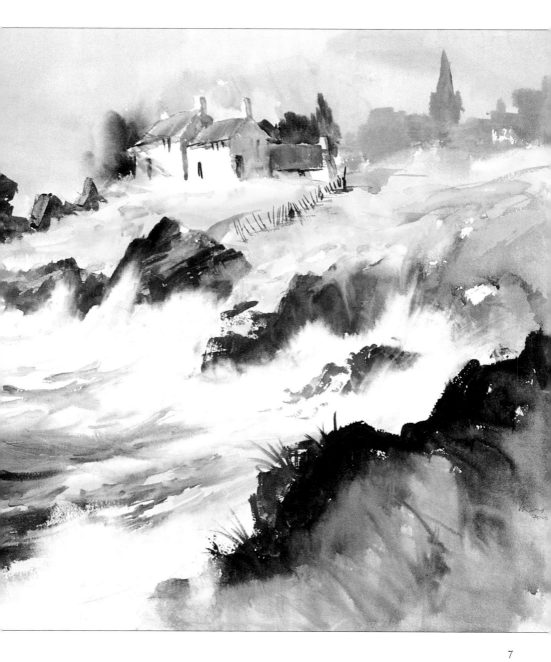

Materials

The wide range of painting materials available can be quite daunting to the beginner, so I hope that the following hints and tips will help you get started. As you become more confident, try out other materials and, gradually, you will develop your own set. However, try to keep your equipment simple – you will be worn out before you start painting if you take the 'kitchen sink' with you!

Paints

Watercolours are available in tubes or solid pans; I prefer to use tube paint because it is instant, and so much more can be done with it.

Artists' quality paints can be expensive, but the less expensive, students' quality colours are quite versatile and are ideal for the beginner. I encourage my students to use tubes of these cheaper paints, so that they do not have panic attacks about their bank balance when I get them to squeeze plenty of paint on to the palette! I am constantly amazed at how mean some students are with their paints. They appear to be quite happy about paying to attend classes, but they hesitate about squeezing anything out of the tube in case they waste it!

Colours

Although there is a vast array of colours available, you can work with quite a limited palette. Some artists prefer to work with just a few colours, others with a very wide range. My palette of colours, which has been refined over the years, consists of the twelve colours shown on page 12. It includes two of each primary colour (warm and cool reds, blues and yellows), three earth colours, and three particular favourites of mine – aureolin, cobalt blue and viridian.

Palettes

There is a very wide range of palettes on the market: large ones for the studio; small ones for site work; flat palettes for water control; palettes with wells for glazing. The best palettes have a lid – if you keep a damp sponge inside them when not in use, the paints will not dry up.

My studio palette, which I designed myself, has a removable lid, sixteen spaces for my colours, a large flat mixing area and two wells for washes.

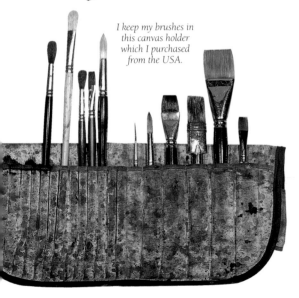

For site work I use a handmade enamelled brass palette, which is a joy to use.

I keep my brushes in this canvas holder which I purchased from the USA.

Brushes

Synthetic brushes are fine to start with, but do treat yourself to better quality brushes when you can afford them.

Sable brushes not only hold more water than synthetic ones, but they also give out paint at a controlled rate. Sable/synthetic brushes are a good compromise. Squirrel brushes are the softest of all, and these are excellent for glazing over other work. Bristle brushes are very useful for lifting out paint, and are perfect for laying washes with lots of water and strong pigment.

Start with just a few brushes; six is a good number. My favourites are: a 25mm (1in) flat sable brush, a 12mm (½in) flat nylon brush with a scraper on the handle, a No. 6 and a No. 10 round sable brush, a No. 3 sable/synthetic rigger brush and a 25mm (1in) flat bristle brush. I own many other brushes, but I rarely use them.

The most common problem beginners have when choosing brushes is trying to pigeon-hole them for specific purposes. It may appear logical that you use round brushes for round shapes and flat brushes for square ones, but you can use them the other way round.

9

Paper

As with the other materials, there is a wide variety of watercolour papers to choose from. Paper manufacturers may have their own recipe for making papers, but there are two characteristics common to most types of paper – the thickness and the surface texture.

The thickness of paper is denoted by its weight, either in pounds (lb) or grams (gsm). The traditional system refers to the weight of a ream of a given sheet size in pounds. Nowadays, most watercolour papers are graded using the gsm system, where the weight is measured in grams per square metre, irrespective of the size of the sheet.

The surface texture of watercolour paper is referred to by the terms HP, Not and Rough. HP, which denotes hot-pressed papers, has a hard, smooth surface; Not, which means not hot-pressed (cold-pressed), is a middle grade that has a semi-rough texture; and Rough which, as its name implies, has quite a rough textured finish.

Always use watercolour paper, even to practice on, as you will never get good results on ordinary papers. Try out different types of papers; many paper manufacturers produce swatches or pochettes – booklets containing small samples of their ranges – and these provide an excellent and inexpensive means of trying out a wide range of paper.

Paper expands when it is wet and, if it is wetted unevenly, some lighter weight papers will cockle out of shape. This 'problem' can be avoided by using medium weight papers, 300gsm (140lb) and above. I attach the paper to my painting board (a sheet of plastic-coated hardboard, slightly larger than my paper), with a couple of spring clips, then start painting immediately.

Easels

There are many easels to choose from, so you need to establish whether you actually need one (remember that you do not have to paint vertically), how much you can afford and the portability you require.

I use a portable, steel-tube easel for all my demonstrations. It is quite rugged – it weighs less than 2.5kg (6lb) – and is erected in seconds. Lighter, aluminium easels are available, but you may have to weigh these down in windy conditions.

If you do not intend to carry your easel over long distances, then a wooden box-easel is superb. It will hold all your equipment and paper, and is extremely solid when erected. However, box-easels can prove to be quite heavy, particularly when full of equipment!

Watercolour paper can be purchased in sheets, pads or in sketchbook form. Painting boards can be made from plywood, MDF or hardboard.

Stretching paper

If you want to use a lightweight paper, and you are concerned about it cockling, you can pre-stretch it on a painting board. Thoroughly wet the paper, use gummed paper tape to secure it to the painting board, then leave it to dry and tighten.

Alternatively, you can ignore any cockling that may occur while you are painting, then stretch the paper when the painting is finished. Thoroughly wet the back of the paper, then 'stick' it, face up, on a sheet of glass.

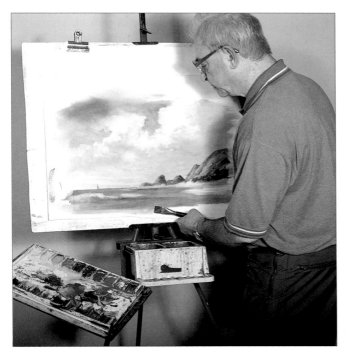

I have customised my metal easel with two home-made accessories: I have an outrigger with a tray for my palette; and a wooden bracket to support my water pots.

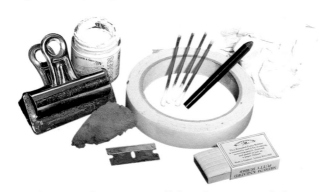

Spring clips, process white, sponge, razor blade, masking tape, cotton buds, paper towel, graphite sticks (or soft pencils) and a putty eraser are all useful additions to your workbox.

Other equipment

Graphite sticks for sketching the outlines of compositions on to the paper. You can use a soft pencil instead.

Putty eraser a very soft and pliable eraser, which I use to remove unwanted pencil lines on the finished painting.

Sponge for lifting colour to create clouds and spray.

Paper towel for lifting out colour, for drying brushes and for general mopping up.

Spring clips for securing watercolour paper to the painting board.

Masking tape an alternative to spring clips for securing paper to the painting board. It can also be used as a mask to create a straight horizon.

Process white an opaque white, not a true watercolour, but very useful for creating highlights.

Razor blade for creating bright highlights, by ripping tiny parts of the paper with the tip of the blade, or soft sparkles by scraping the flat blade across the paper.

Water sprayer (not shown) for wetting watercolour paper prior to laying a wash.

11

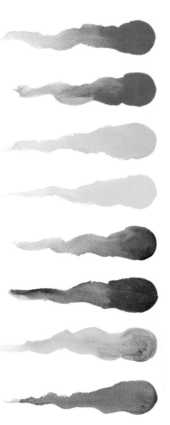

Mixing colours

Colour mixing can be a daunting task, and one of the questions I am frequently asked is: 'How do I get clean colour? All I get is mud' On these and the following pages, I explain my method of mixing colour which, I hope, will simplify your understanding of this subject. My palette of colours is shown left, and you will note that I classify them as being clean, dirty or other colours.

Clean colours

We all know that pairs of the three primary colours, red, yellow and blue, can be mixed to make the secondary colours, orange, green and purple. However, there are no perfect reds, yellows and blues; each has a touch of at least one of the others in it. Reds, for example, either have a tinge of yellow to make them warm, or a tinge of blue, to make them cool. To make clean secondary colours, it is vital that you have a warm and cool shade of each primary colour in your palette; the colour wheel opposite shows my colours and the relationship between them.

My greens, for example, are mixes of Winsor blue (which has a touch of yellow in it) and lemon yellow (which has a touch of blue). Neither of these colours has any red in them so the result is a beautiful clean green. Similarly, clean purples are mixes of the cool permanent rose and warm ultramarine blue (neither colour has any yellow in it), and oranges are mixes of warm cadmium scarlet and warm cadmium yellow.

Dirty colours

The introduction of a third primary colour will grey the mix into what I refer to as a dirty colour. I classify the earth colours, raw sienna, burnt sienna and burnt umber, and all mixed browns as dirty colours because they contain three primary colours. However, dirty colours are not muddy, they are neutral greyed colours which still remain quite transparent. Sometimes, you will want to dirty a clean colour to make it less intense. Try mixing a purple from cadmium scarlet and Winsor Blue (both of which have tinges of yellow) and note how less intense the colour is compared to the clean mix mentioned above.

My palette of colours (from the top):

Clean:	Permanent rose	*Dirty:*	Raw sienna	*Other:*	Aureolin
	Cadmium scarlet		Burnt sienna		Cobalt blue
	Cadmium yellow		Burnt umber		Viridian
	Lemon yellow				
	Winsor blue				
	Ultramarine blue				

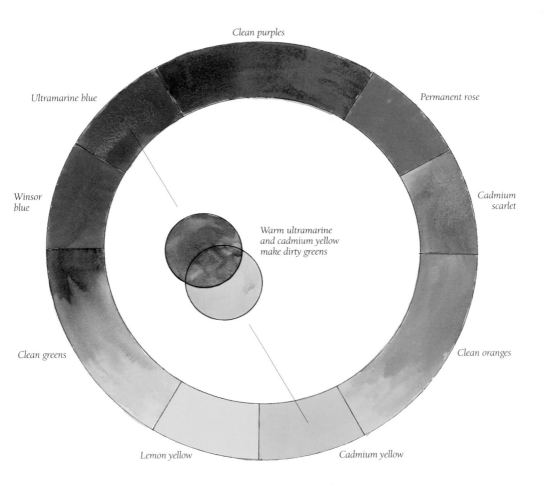

Clean purples

Ultramarine blue

Permanent rose

Winsor blue

Cadmium scarlet

Warm ultramarine and cadmium yellow make dirty greens

Clean greens

Clean oranges

Lemon yellow

Cadmium yellow

My other colours

The other colours in my palette, aureolin, cobalt blue and viridian, are there simply because they are particular favourites of mine. Aureolin is a slightly golden yellow which has a high transparent quality. Cobalt blue is nearly a perfect blue and highly transparent. Viridian (not one of Nature's greens) is quite transparent which can be mixed with permanent rose (also transparent), to produce highly transparent greys.

Muddy colours are produced by applying too many layers of paint. These layers stop the light from reflecting off the watercolour paper giving the resultant colour an opaque quality.

13

Mixing greens

My students often ask me how to mix greens. I, in turn, ask them three questions to describe the colour they want to reproduce. Is it a warm or cool green? Is it a light or dark shade? Is it a clean or dirty colour? Answer these three questions and you can begin mixing the colour in your mind, before you even pick up a brush. Always start mixing with the palest colour, then add tiny amounts of the darker one(s).

If, for example, you describe the green as being cool, dark and dirty, all three primary colours are required. Start by squeezing some cool lemon yellow into your palette. Next, nudge in a cool Winsor blue until the green is dark enough. Then, finally, add a touch of a red (either cadmium scarlet or permanent rose) to dirty it down slightly.

Other shades of green can be cool and bright or warm and slightly dirty. Mixing them is only a matter of practice, as is anything worthwhile.

The colour mixes on this page clearly illustrate how you can achieve a wide variety of tones by mixing just two pigments.

Useful greens

Viridian and raw sienna.

Winsor blue and raw sienna.

Viridian and burnt sienna.

Burnt umber and Winsor blue.

Greys and blacks

Viridian and permanent rose.

Ultramarine blue and cadmium scarlet.

Winsor blue and burnt sienna.

Burnt umber and ultramarine blue.

Tonal values

Many artists try to create a range of tones in their paintings, placing the lightest lights against the darkest darks, and this method of painting is often referred to as tonalism. I admire many painters, Rowland Hilder in Great Britain and Andrew Wyeth in the USA, for example, who use this principle as the dominant force in their paintings. However, there are other concepts which can be used to create different moods in your painting. These could be: warm colour against cool colour, clean colours against dirty ones; textured shapes against smooth shapes; and rough edges against soft edges (See also pages 20–21).

Light against dark will always be the dominant concept, since the light/dark sensors in our eyes are far more powerful that our colour ones. So, if you want to stress the colour in your painting, then a good concept would be to use clean against dirty colours. This means that you must subdue most of the light/dark contrasts and eliminate any white. White in a painting says to any colour, 'I am lighter than you'.

These two colour sketches illustrate the difference between a painting where light against dark is the dominant principle, and one where clean colours have been used against dirty ones.

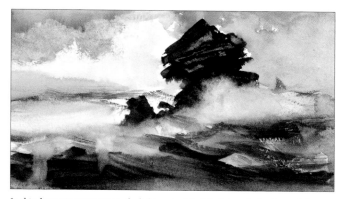

In this dramatic composition, the light against dark technique is dominant. It has interesting shapes with edge qualities ranging from hard to rough to smooth. The lightest light meets the darkest dark in the area of the painting I want you to end up looking at – the focal point.

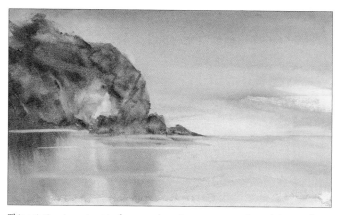

This painting, in contrast to the scene above, imparts a tranquil mood. Essentially, it is a clean against dirty painting. The strong light/dark elements have been subdued to allow colour to become the dominant feature. Note, however, that the dirty colours are not muddy – they actually appear to glow!

Useful techniques

Handling brushes

The way you present a loaded brush to the surface of the paper affects the way pigment is applied.

If you hold a loaded brush at right angles to the paper and move it across the surface, the tips of the hairs reach down into the troughs in the surface texture, and pigment is applied to the whole surface of the paper. Use this technique for laying washes and for blocking in.

If you hold the brush so that the hairs are parallel to the paper, then drag the brush across the surface, pigment only sits on the top of the textured surface, creating a sparkle effect. This brush technique is ideal for indicating the edges of foliage and moving water.

Applying washes

For large areas of colour, such as skies, I use a 25mm (1in) flat bristle or sable brush.

Some artists lay a wash by making parallel horizontal strokes of a loaded brush, carefully catching the bead of water as they work down the paper. I prefer to create my skies in a painterly way, brushing colour quickly and freely in all directions – the result is a fresh, clear sky.

Sponging

A sponge is ideal for creating highlights on rocks and for denoting the softness of foaming water.

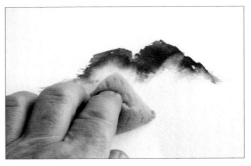

Paint in the rock, using quite dry mixes of colour, then, while it is still wet, push a clean, damp sponge into the edge you want to soften. Clean the sponge after each stroke or you will push pigment back into the area you have just lightened.

Scraping into wet

My 12mm (½in) flat scraper brush is wonderful for pulling out trees, branches and grasses from dark areas, and for cutting out the sunlit sides of rocks. Ensure there is enough pigment in the background tone to allow you to scrape lighter marks. The paint should be damp, not wet; if there is too much water on the paper, you will end up cutting a trough and the pigment will drop into it, producing a dark line.

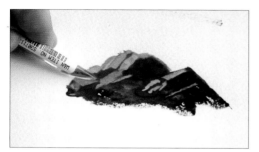

Use the scraper as you use a knife to scrape butter off toast and you will have no problem. Hold the brush down low, angle the flat of the scraper blade, then push it firmly across the paint. Pushing it sideways produces a thicker line as more of the edge comes in contact with the paper.

Using a rigger brush

Rigger brushes come in various sizes, but I prefer to use the No. 3 size. As its name suggests, this brush was originally designed for painting the rigging of ships. The long hairs hold a relatively large reservoir of water, which can be released quite slowly to create extremely long lines. The rigger brush can be used for branches, twigs and grasses, and for adding fine textural detail.

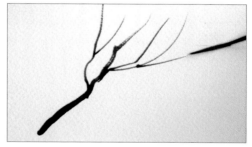

When the brush is placed hard (up to the ferrule) against the paper it produces a thick line; as it is drawn backwards and upwards, the line narrows progressively – ideal for bare winter branches.

Using paper towel

Paper towel is useful for pulling out hard, crisp shapes from skies. It can also be used to lift out the peaks in waves.

Scrunch up a paper towel, then press this on the wet paper to lift out colour and create hard-edged clouds.

Using razor blades

Razor blades can be used to produce the tiny bright sparkles created by the spray from a breaking wave. This technique works best against the dark tones.

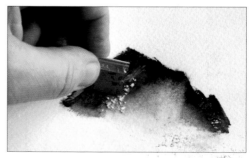

Use the tip of the blade to nick out tiny pieces of colour when the paper is completely dry.

Controlling of water

The control of water is, perhaps, the greatest stumbling block when learning to paint in watercolour. You must decide where your water needs to be. For most techniques where you want to control the pigment, the water should be either on the paper, in the palette or on the brush. On these pages I introduce some techniques which will help you control your water and yourself!

Glazing

If you mix colours in the palette and apply it to dry paper, the pigments merge and they will all dry together. When this wash is completely dry, another wash can be glazed on top. More than three washes will start to destroy the luminosity of watercolour, as the light needs to travel through the washes and bounce back off the paper.

It is most important that you clean your brush, and remove all excess water, before reloading it with fresh paint. Otherwise, it will be like putting a wet sponge into a puddle; it will not pick anything up.

Backruns

Backruns (sometimes referred to as cauliflowers) are created when water is added to partly-dry paint; the water leaches into the drier areas of paint causing strange cauliflower-like shapes. Sometimes, this effect can be put to good use to depict, for example, ground mist at the base of a forest.

Lifting out wet paint

You can lift shapes out of wet paint with a 'thirsty' brush – a term which means that the brush has less water in it than is on the paper, so that, when the brush touches the paper it soaks up water and pigment. All the shapes lifted out will have a slightly soft edge. Clean the brush and wring out excess water each time to lift out colour.

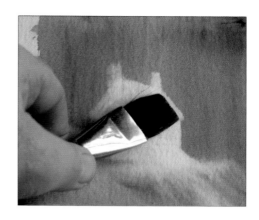

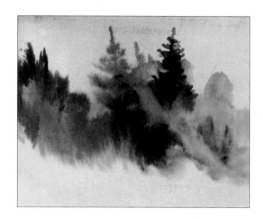

Dry into wet

This technique also uses a thirsty brush and involves applying neat colour into a wet area; it is particularly effective for waves, misty trees, etc.

Apply clean water or wet paint to the area, ring out a clean brush, pick up neat pigment, then paint it into the wet area. Because the brush is drier (or thirstier) than the wet paper, it draws water from the paper and drops on new pigment without it spreading. This happens because the new area is relatively drier than that around it. The wet area attacks the edge of the drier area and softens it. Lighter values of tone can be applied in this way by dragging out some of the pigment on a dry palette before application.

Mingling

For this technique, the paper is first wetted with clean water, then colours are pumped into the wet area – the pigments mix together and dry as one glaze to give maximum luminosity.

Having wetted your paper, mix your colour with water to the required tonal strength on a flat palette. Wring out the brush, then pick up the paint in one stroke and paint it straight into the wet. There should be just enough water in your brush to allow you to add pigment into the wet without lifting paint back out. You can keep painting this way for five minutes providing you keep the paper wet and mingle clean, colours of the same tonal value.

Designing a painting

Degas said that it is easy to paint a picture when you do not know what you are doing. However, if you blindly set up your easel and start to paint what is in front of you, you are very likely to get a poor result. Nature is a poor artist – she plants all the seeds in the wrong places!

When you have decided on a particular scene to paint, have a good look around and observe the subject from various positions, and take time to consider the following points. Remember that you can leave out anything that will distract the eye from the main subject.

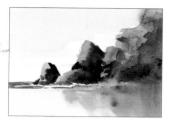

A full view of the scene in front of you can produce a pleasing composition...

Focal point

A painting needs a focal point on which the eye can settle. This can be a solid object, such as a rock, or just an indefinable area to which the eye is led by the shapes, tones and colours around it. Place the focal point in a position that looks right, preferably just off-centre. I often use the 'golden section' format, which positions the focal point roughly one-third in from adjacent sides.

You can choose to paint all of the scene in front of you, but do consider painting just part of it at a larger scale. The two sketches (right) were drawn at the same location; note how the closer view is more dramatic than the other.

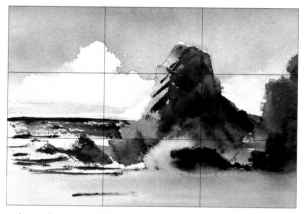

... but a selective view of the distant rock gives the opportunity of creating some interesting shapes and textures. I have superimposed the golden section format on this sketch to illustrate how to position the focal point.

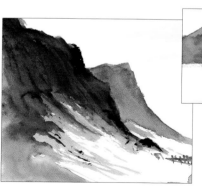

These two compositions are of the same subject. The one above, although true to life, lacks interest. Move to a different viewpoint, and the shapes and textures become far more interesting.

Shapes

Good shapes make great pictures. Try to create shapes that are not predictable in size and direction, and which have a variety of hard, soft and rough edges. Again, find a viewpoint that gives you the most interesting shapes, or simply change them into more interesting ones. All the great artists did this!

20

Tonal values

Tonal values can affect the mood of a painting, and the three examples (right) illustrate this point. However, there are no hard and fast rules, and you do not have to range the tones from the lightest light to the darkest dark. For instance, a misty morning requires a very restricted range of tonal values to create its mood.

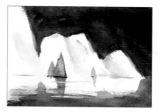

Mid tones against light against dark.

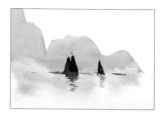

Dark against mid tones against light.

Colours

The temperature of the colours you use also affect the quality and mood of a painting. Do not blindly paint the grey-greens and blue-greens that are there. Choose colours that express the mood that inspired you to paint the picture. The two sketches below – one in warm colours, the other in cool ones – clearly show how the choice of colours can create entirely different images of the same scene.

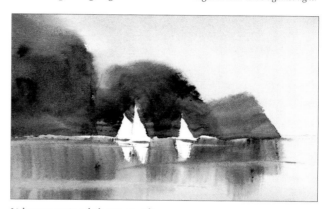

Light tones against dark against mid tones.

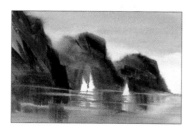

Cool colours.

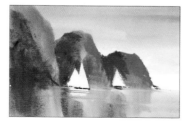

Warm colours.

Edges

The type of edge you give your shapes has a dramatic effect. Shapes with hard edges appear to be 'stuck on', and not part of the painting. Vary the edge quality (soft, hard, rough, etc.) and you will stitch the shape into the painting with what is referred to as the lost-and-found-edge technique. Some objects would not look real without a certain edge quality; running water, for instance, must have soft or rough edges, whilst still water should have harder ones.

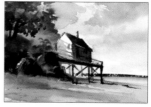

Hard edges.

Soft edges.

Painting skies

It is impossible to illustrate all the different skies you may encounter – they change by the second – but, here, I show you a few of the more common types, and I suggest points for you to consider when painting them.

A clear 'blue' sky is not the same blue all over, and it can range from a deep, purply blue high up, down to a pale, eggshell blue near the horizon. Similarly, clouds are not always white; they can vary from being very light against a dark sky to quite dark against a light sky.

Remember the rules of perspective; clouds directly overhead are much larger than those in the distance. They also pack closer together as they recede. The tops of low clouds against a bright sky have crisp, hard edges, whereas their undersides usually have soft edges.

Really high clouds can be quite wispy, or they can cover the whole sky and take up some wonderful pastel tones.

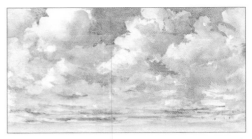

These clouds overlap each other and create interesting silhouettes. Note that the largest clouds are near the top (front) of the composition and that they become smaller as they get further away. Note also how the background sky colour becomes cooler as it recedes into the distance.

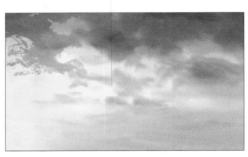

I started this evening sky with a background of aureolin. While the paper was still wet I used the mingling technique to pump permanent rose and cobalt blue into the lower, more distant part of the sky. I then applied darker mixes, made with ultramarine blue and cadmium scarlet, into the higher, closer cloud formations.

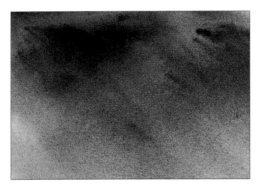

This detail shows rain clouds which have a diagonal direction created by the prevailing winds. To achieve this effect, the sky was first painted with a suitable background colour and allowed to dry. A strong dark was painted into the top left-hand corner, then the paper was immediately tilted to an angle of about 60°, corner to corner. A small spray gun, held far enough away from the paper for the water to atomise, was then used to wet the paper until the applied colour slid diagonally across the paper of its own accord.

Clouds can be quite pale against a dark sky...

...or dark against a pale sky.

Painting seas

It is important to get to know the sea and the seashore before you start painting, and, to this end, I suggest you take every opportunity to walk along the coastline irrespective of the weather conditions. Take a sketchbook with you and try to capture all the different moods you see.

Note, for instance, how the swells on the surface develop into breakers, then crash against the rocks creating lots of spray. Watch how the water cascades off the rocks and, then, how this turbulence produces foamy patterns.

Light direction changes throughout the day, so take note of how various lighting conditions affect colour and tonal values. Atmospheric conditions also have a profound effect; the horizon can be dark and clear, or so pale it almost merges with the sky.

The sea reflects the colours in the sky; so it is no use painting a warm, ultramarine blue sky and a cool, Winsor blue sea. This is a common problem, and I have seen many seascapes ruined by having completely different colours for the sea and sky.

Remember that the sea is moving all the time – tides ebb and flow – and the shapes in the sea are changing continually. The texture of the edges of shapes is important; rough or soft edges show movement, whereas hard edges give the impression of stillness. Note how reflections become more prominent when there is little movement in the water, and how the angle of the light creates different highlights and shadows.

Armed with your observations and trial sketches, establish what mood you want to paint. Decide on a focal point – a lighthouse, a boat or just a large wave – then place it so that it draws the eye into the composition. Then, I suggest you try out a few tonal sketches to clarify your mind. You will soon gain the confidence to begin painting seascapes.

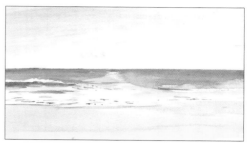

This beach scene shows how the colours of the simple sky are reflected in both the gently moving sea and the wet sand. The waves are too far away to need much detail.

The dominantly horizontal design of the shapes in this composition, together with the hard edges of the horizon and the reflections of the boat indicate a very calm sea.

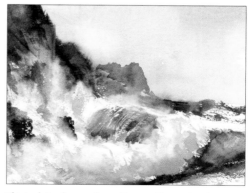

This is obviously a rough sea. The use of interesting shapes with rough and soft edges is vital to create the right mood.

Gower Coast

For this first project, I have chosen a simple seascape where the sky is the largest and, therefore, the most important part of the painting. The low horizon, approximately one-quarter of the way up the paper still provides adequate space to create an interesting foreground to lead the eye into the painting, and the small yacht provides a focal point. The silhouette of the rocks which link the sea and sky have unpredictable shapes to create the maximum interest.

Although I painted this demonstration on a 660 x 460mm (26 x 18in) sheet of 535gsm (250lb) Not paper, I worked within an aperture of 510 x 330mm (20 x 13in) to create a wider vista.

You will need

Brushes: 25mm (1in) flat bristle, 25mm (1in) flat sable, 12mm (½in) flat nylon with a scraper end

Colours: aureolin, burnt sienna, burnt umber, cadmium scarlet, cadmium yellow, cobalt blue, permanent rose, ultramarine blue

Other equipment: paper towel, razor blade

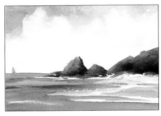

Tonal sketch
Having made this sketch, I decided to lower the horizon and develop the sky, breaking it up into a variety of interesting shapes.

1. Transfer the basic outlines of the composition on to the paper.

2. This sky must be painted quickly, so prepare washes of aureolin, cadmium scarlet, cobalt blue and ultramarine blue in advance. Then, start the sky by using a 25mm (1in) flat bristle brush to wet all the paper.

3. Lay in a few random strokes of aureolin across the middle of the wetted sky area.

4. Use the cobalt blue wash to block in the top part of the sky behind the clouds.

5. At the right-hand side of the sky, brush random strokes of a weak wash of cobalt blue, then drop in some permanent rose and cadmium scarlet. Allow all the colours to blend together.

6. Lay in more cobalt blue to redefine the top edges of the clouds...

7. ...and to darken the lower sky behind the headland

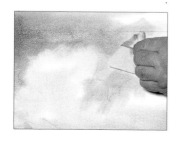

8. Use a paper towel to lift out colour and soften the top edges of the clouds.

9. Quickly push colour across the paper with a paper towel to form streaks of wispy cloud.

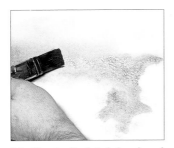

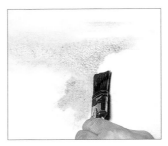

10. Use the flat bristle brush and a 'negative painting' technique to add more cobalt blue to define the edges of large clouds . . .

11. . . . then use a damp clean brush to vary the edges of the clouds to give them a 'lost and found' effect.

12. Use more cobalt blue to add some wispy clouds at the bottom left-hand side of the sky.

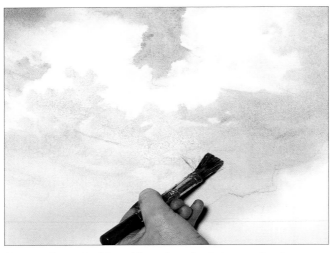

13. Mix ultramarine blue with touches of cadmium scarlet, then start adding darker clouds. Move the brush quickly and lightly across the paper for some shapes, then touch the paper gently with the brush almost flat to create some rough edges.

14. Again, use a clean brush to soften some of the hard edges that start to form.

15. Lay in a few wispy clouds in the distant sky just above the horizon line.

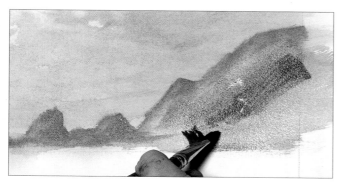

16. Mix ultramarine blue with touches of burnt sienna, then use the 25mm (1in) flat sable brush to block in the headland. Add touches of cobalt blue for the more distant rocks. Add cadmium yellow to the mix, then drop this into the near headland. Use the colours on the palette to accentuate edges, and to build up shape and tone.

17. While the colours are still wet, use the scraper end of the 12mm (½in) flat nylon brush to scratch highlights in the rocks.

18. Use mixes of cobalt blue and ultramarine blue, and the flat sable brush to lay in the sea; Make long sweeping horizontal strokes, leaving some areas of sparkle on the surface. Add touches of cadmium scarlet to the distant water.

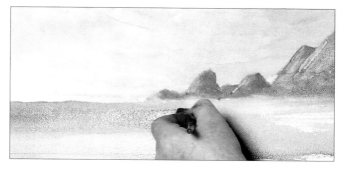

19. Use the tip of the brush to make the horizon line straight and horizontal.

20. Use a clean damp brush to lift out some wave shapes.

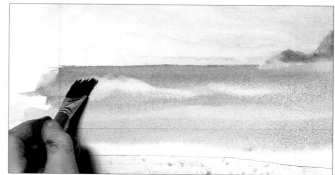

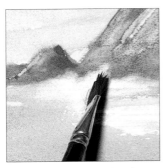

21. Use a clean damp brush to push colour up into the headland to create spray.

22. Use mixes of ultramarine blue and burnt umber to create rocky shapes on the headland.

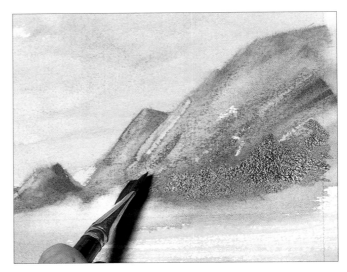

23. Use the scraper end of the 12mm (½in) flat nylon brush to create highlights and shape.

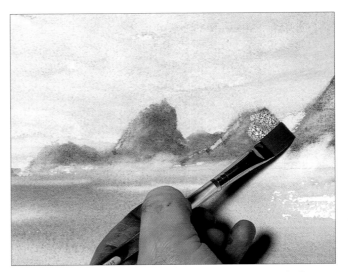

24. Darken the middle distance rocks to create depth, and shadows, and, if necessary, rework some rocks to eliminate any repetitive shapes.

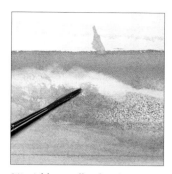 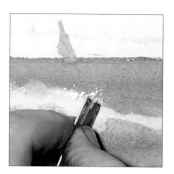

25. Add a small sailing boat on the horizon as a scaler, then use a rigger to add shape and detail to the wave at the left-hand side.

26. Use the corner of a razor blade to nick out fine speckles of spray on the left-hand wave.

27. Then, finally, draw the razor blade horizontally across the distant sea to create some lively areas of sparkle.

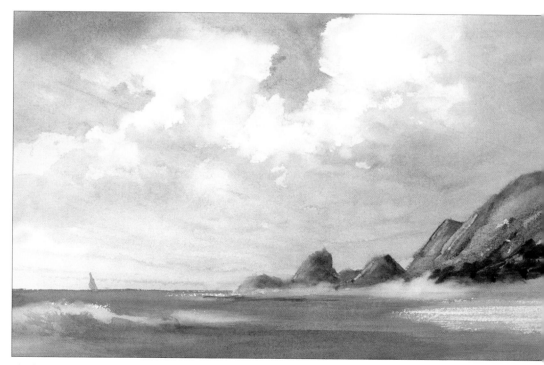

The finished painting
Size: 510 x 330mm (20 x 13in)

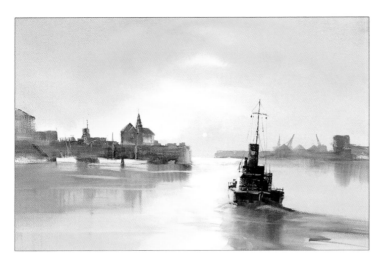

Cardiff Docks
Size: 660 x 460mm (26 x 18in)

In this composition, the sky and sea were created by mingling random strokes of aureolin, permanent rose and cobalt blue. The buildings and reflections were applied with a thirsty brush using ultramarine blue and cadmium scarlet

The tugboat, also painted with ultramarine blue and cadmium scarlet, was added when the background was completely dry to ensure crisp hard edges.

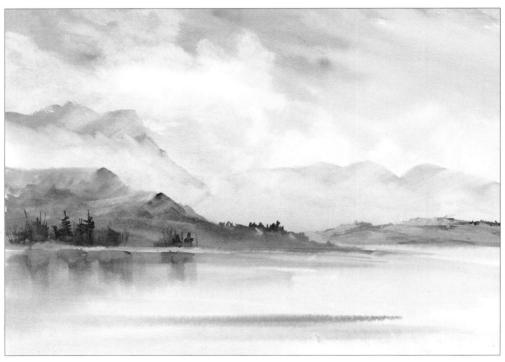

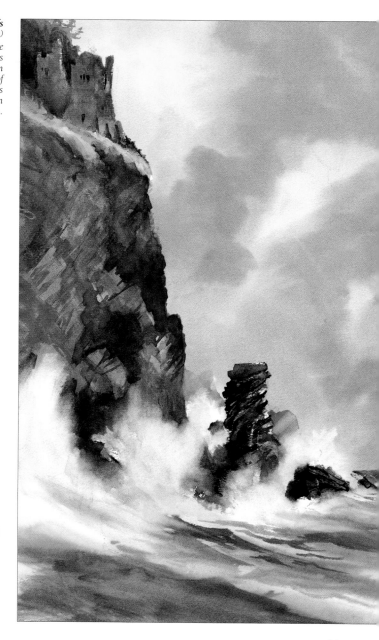

Cliffs
Size: 305 x 510mm (12 x 20in)

The soft edges in this painting were
achieved by applying most of the colours
while the paper was wet. The spray from
the breaking waves was sponged out of
the rocks and sky, then the actual waves
were applied with a thirsty brush, again
to eliminate hard edges.

Opposite
Early Morning Mist
Size: 460 x 330mm (18 x 13in)

The atmospheric effect of this painting
was produced by dragging a paper towel
diagonally across the mountains to
break up their edges, and by sponging
their bases to create the mist. The
reflections were produced by using a
thirsty brush to drag paint from the
rocks into the water area, whereas the
highlights in the water were created by
using a thirsty brush to lift out colour.

Reflections in the Sand

In this scene, the receding tide leaves large shallow pools of water on the beach which produce wonderful soft reflections. Distance is emphasised by aerial perspective; the colours used to depict the cliffs gradually change from warm to cool as they get further away. The diagonal shape of the large foreground rocks provide a point of interest and creates a 'path' to lead the eye into the distance. The diagonals in the sky, opposite to those in the cliffs, create a balanced composition. I painted this demonstration on a 660 x 460mm (26 x 18in) sheet of 300gsm (140lb) Not paper, in a 510 x 400mm (20 x 16in) aperture.

You will need

Brushes: 25mm (1in) flat sable, 12mm (½in) flat nylon with scraper end, No. 3 rigger

Colours: aureolin, burnt sienna, cadmium scarlet, cobalt blue, lemon yellow, permanent rose, raw sienna, ultramarine blue

Other equipment: sponge, paper towel, razor blade

Having made this tonal sketch, I then decided to make the left-hand cliff slightly lower and make its top visible (see step 1). However, while painting the scene, I changed my mind again (see step 9), and reinstated the full-height of the cliff face.

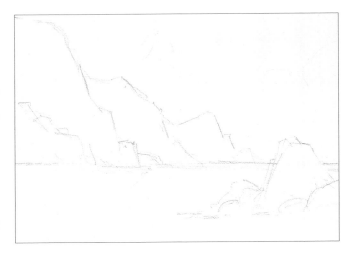

1. Sketch the basic outlines of the composition on to the paper.

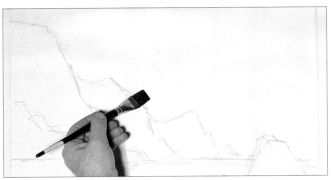

2. Prepare weak washes of aureolin, permanent rose and cobalt blue. Start the sky by using the 25mm (1in) flat sable brush to wet the whole sky area, taking the water just across the outlines of the headland and the rocks.

3. Working quickly, lay random streaks of aureolin across the middle of the sky...

4. ...then brush the permanent rose randomly over the yellow...

5. ...and, while the first colours are still wet, lay in the cobalt blue to shape out the clear areas of the sky...

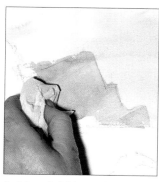

6. ... then, finally, use a clean brush to soften some of the hard edges that start to form. Leave to dry.

7. Mix cobalt blue with a touch of permanent rose, then block the distant headland. Make diagonal strokes with clean paper towel to wipe out some of the hard edges.

8. Add touches of lemon yellow to the grey mix, then block in the next nearest cliff with different tones of this colour. Again, use paper towel to soften some edges.

9. Add raw sienna and burnt sienna to the mix, then block in the nearest cliff. Vary the colour with touches of permanent rose. Notice that I have increased the height of the foreground cliff.

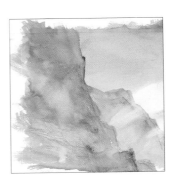

10. Mix cobalt blue with a touch of cadmium scarlet, then start adding shadows into the distant headlands. Strengthen the mix to add shape and texture.

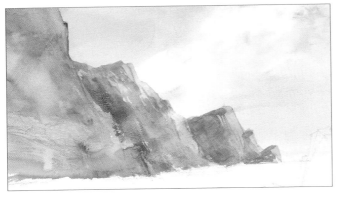

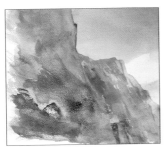

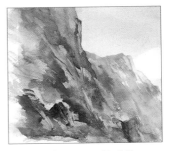

11. Apply random strokes of clean water to the near headland, then use mixes of burnt sienna and ultramarine blue to add darks and create texture.

12. Use the scraper end of the 12mm (½in) flat nylon brush to scrape rocky shapes into the wet areas of colour.

13. Use the 25mm (1in) flat sable to strengthen the burnt sienna and ultramarine blue mix, then continue to develop shape and texture. Use a clean brush to soften some edges. Leave to dry.

14. Add more burnt sienna to the mix to form a really dark colour, then paint this on the middle distance headland to bring the edge of the foreground cliff into relief. Soften the right-hand side of this colour with clean water. Bring the edge of the middle distant headland into relief in a similar manner, by using cobalt blue on the far headland.

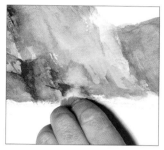

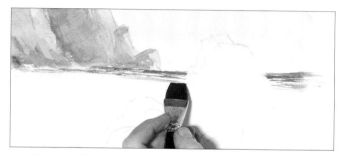

15. At sea level, push a clean damp sponge into the darks to indicate a small area of spray.

16. Mix cobalt blue with a touch of lemon yellow, then use short vertical strokes of the 25mm (1in) flat sable brush to create small waves on the distant sea.

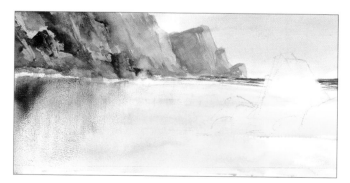

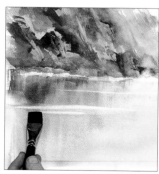

17. Wet the area of sand with clean water, then lay in a wash of raw sienna. Add touches of burnt sienna into the foreground, then, working quickly with a thirsty brush, lay in vertical strokes of the colours used for the foreground cliff .

18. While the paint is still wet use a clean thirsty brush to lift out horizontal strokes across the beach to emphasise the reflection.

35

19. Prepare a stiff mix of burnt sienna with touches of raw sienna, then, using the side of the brush to create sparkle and texture, start to block in the foreground rocks.

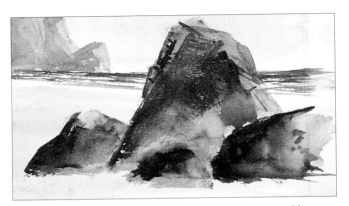

20. Add highlights with a mix of raw sienna and ultramarine blue, then use the darker mix to continue building up shape and texture.

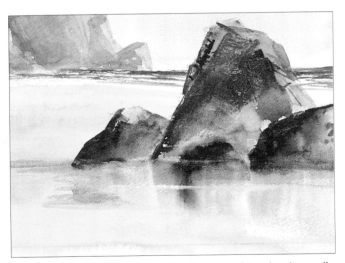

22. Mask the top of the painting, then spatter a few dark spots of colour across the foreground. Elongate some of these by wiping across them with short horizontal strokes of a clean paper towel.

21. Wet the area in front of the rocks, then use a thirsty brush to pull the rock colours down into the wet area to create reflections.

23. Finally, use a razor blade to rip the paper and create bright sparkles on some of the rocks.

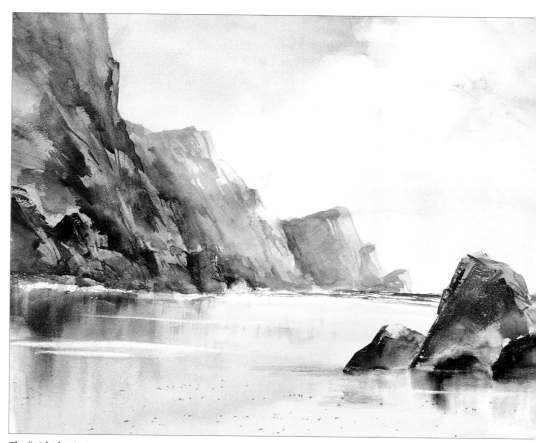

The finished painting
Size: 510 x 400mm (20 x 16in)

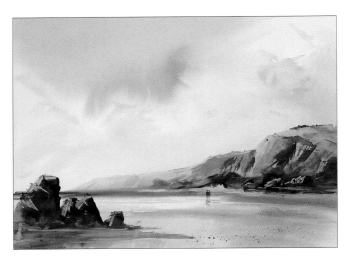

Low Water
Size: 685 x 510mm (27 x 20in)

This painting was executed in a similar way to the demonstration painting on pages 32–37, but the paper was kept wet longer to give a softer effect. The final addition of two people walking on the beach provides a scale for the eye to appreciate the physical size of the beach.

Below
Caldy Island Lighthouse
Size: 720 x 500mm (27 x 20in)

This image was painted on 190gsm (90lb) Not cotton paper. The soft-edged effect was created by completely wetting the paper before adding any colour. The lighthouse provides the focal point, and the gap in the cliffs leads the eye from the sea up across the island.

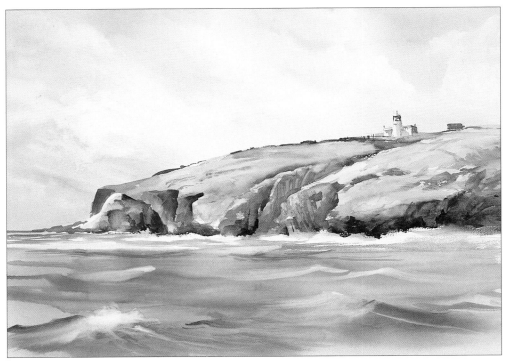

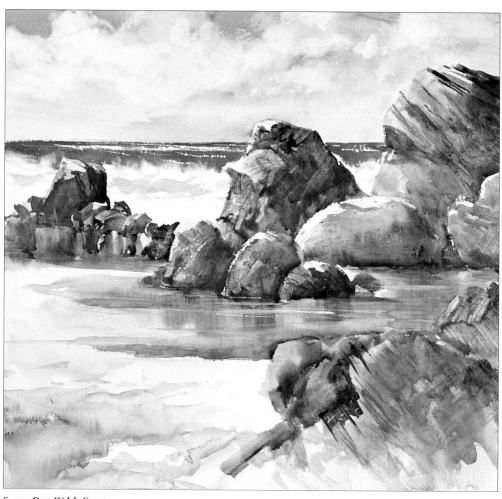

Sunny Day, Welsh Coast
Size: 510 x 510mm (20 x 20in)

In this painting of a rocky beach, I contrasted the rough sea against the tranquil rock pool. The rocks have a variety of colours and edge textures to make them more interesting. The light, coming from the left-hand side of this composition, produces shadows which contrast with the sunlit sand.

Rough Seas

Waves crashing against rocks are one of my favourite subjects, so I had to include this composition of a stormy seascape as a step-by-step demonstration. Such paintings must reflect the mood of a stormy day, and the use of many diagonal shapes will help produce this effect. The use of a portrait format emphasizes the height of the cliffs and adds to the dramatic mood. I use a lot of thirsty brush work and sponging out techniques to achieve my intent on a 400 x 510mm (16 x 20in) sheet of 300gsm (140lb) Not paper. The cool colours of the sky and sea are balanced by the warmer ones used for the castle, headland and rocks.

You will need

Brushes: 25mm (1in) flat sable, 12mm (½in) flat nylon with scraper end, No. 3 rigger

Colours: aureolin, burnt sienna, cadmium scarlet, cadmium yellow, cobalt blue, lemon yellow, permanent rose, process white, raw sienna, ultramarine blue

Other equipment: sponge, cotton buds

Tonal sketch
Note the variety of diagonals which lead you to the castle. The overall shape of castle, headland and rocks has an unpredictable quality in both direction and edge which gives a lot of interest.

1. Use a soft pencil to transfer the basic outlines of the composition on to paper.

3. While the colours are still wet, use a clean damp sponge to push colour upwards into the dark sky to signify spray...

2. Use the 25mm (1in) flat sable brush to wet the sky area, then lay in random strokes of cobalt blue. Working wet-into-wet, drop ultramarine blue in the top part of the sky, then lay in permanent rose and touches of raw sienna. Darken the bottom of the sky with more ultramarine blue.

4. ... use cotton buds to pull out the wispy edges of spray...

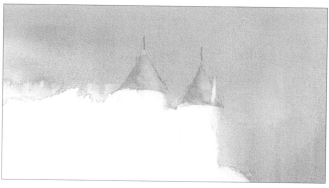

5. ... then use a thirsty 25mm (1in) flat sable brush to lift out just the light parts of the roof tops. Leave to dry.

6. Mix cobalt blue and lemon yellow, then paint the roof shapes and the spires. Note how the sky colour left in at step 5 creates shape and form. Use a cotton bud to pull out the chimney.

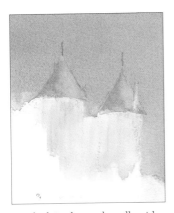 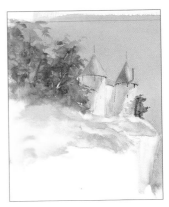

7. Block in the castle walls with aureolin, then, while the paper is still wet, mingle in some cadmium scarlet.

8. Mix cobalt blue with a touch of permanent rose, then lay in the shadows on the roofs and walls of the castle. Soften the edges with a clean brush. Mix a dark tone from cadmium scarlet and ultramarine blue, then use a rigger to add details to the castle.

9. Use burnt sienna, lemon yellow, ultramarine blue and cobalt blue to mix a variety of greens, then lay in the foliage. Use a rigger to denote a few tree trunks, then scratch out a few more with a scraper. Block in the grasses with mixes of cadmium yellow and raw sienna. Add a few shadows on the grassy areas.

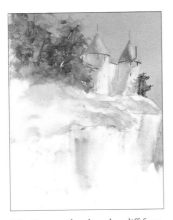 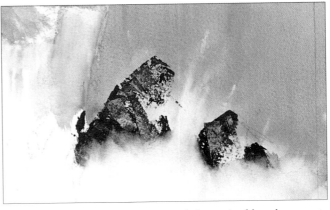

10. Start to develop the cliff face with random strokes of raw sienna, burnt sienna, and ultramarine blue.

11. Make a stiff mix of burnt sienna and ultramarine blue, then start to paint the rocks by dragging the brush across the surface to leave lots of white sparkles (see page 16). Push a clean damp sponge up into the rocks to create spray.

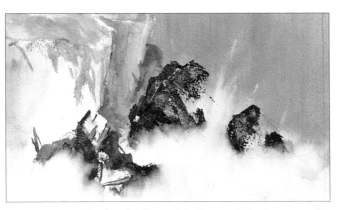

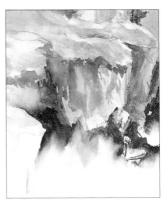

12. Continue to develop the shape of the large rock, lay in more rocks in the foreground, then add shadows to the face of the cliff. Again use a sponge to soften the bottom edge of the rocks. Add the indication of a distant rock to accentuate the right-hand side of the cliff.

13. Use mixes of ultramarine blue and cadmium scarlet to add more shape, shadows and texture to the cliff face. Try to create interesting shapes, and work lights against darks.

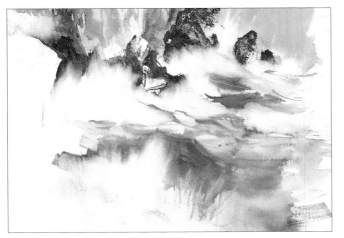

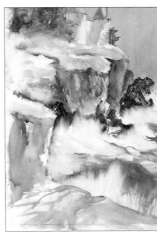

14. Wet the sea area. Use flat strokes of a thirsty brush and cobalt blue to start laying in the waves. Add a touch of permanent rose, then add more waves. Mix a weak wash of ultramarine blue and cadmium scarlet, then wash in the foreground. Use a rigger to add fine lines. Use a clean damp sponge to soften the tops of the waves and to create spray in the foreground. Use a cotton bud to draw colour down into the spray.

15. Use the flat sable brush and mixes of raw sienna and burnt sienna to block in the foreground rocks. Mix cobalt blue and cadmium scarlet, then add shadows to the rocks and cliffs.

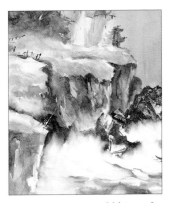

16. Use a rigger to add hints of foliage to the top of the right-hand cliff, to accentuate the right-hand edge of the distant cliff, and to add more darks to the cliff face.

17. Finally, apply small amounts of process white with your finger, making gentle movements in the direction of the waves. This technique produces rough white edges that add more texture to the spray on the large rocks.

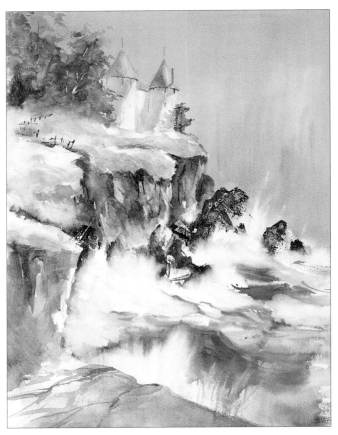

The finished painting
Size: 330 x 445mm (13 x 17½in)

Dawn over the Gower Coast
Size: 520 x 340mm (20½ x 13½in)

The mood of this painting was achieved by contrasting warm colours against cool ones. The whole area of sky was completed before any of the colours dried out; this ensured that all edges stayed quite soft and that maximum luminosity was retained.

The rough sea and crashing waves were painted in a similar way to those for the demonstration on pages 40–44. Much of the spray was sponged out, but I also created brighter areas by applying opaque process white with my finger.

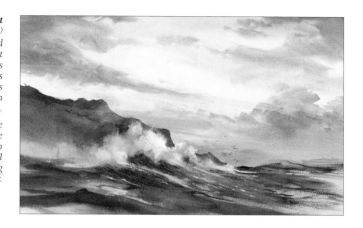

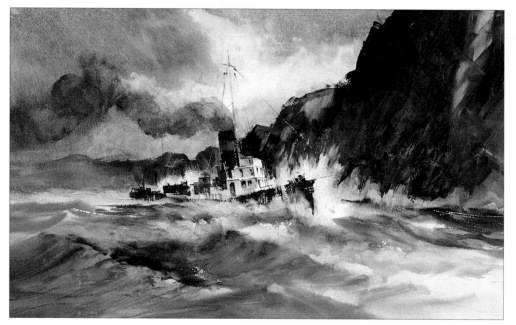

'Sea Alarm' in Rough Weather
Size: 635 x 400mm (25 x 16in)

Dramatic compositions such as this rely on the contrast of light against dark. It is important to make the main shapes stand out, so I highlighted the bridge of the boat against the dark cliffs, and added spray behind the hull to emphasize the shape of the bow and stern. For the smoke, I mixed ultramarine blue and burnt sienna, then used my finger to apply it, rubbing it on the paper in a circular motion. The bright speckles of foam on the breaking waves were created by ripping the paper with a razor blade.

45

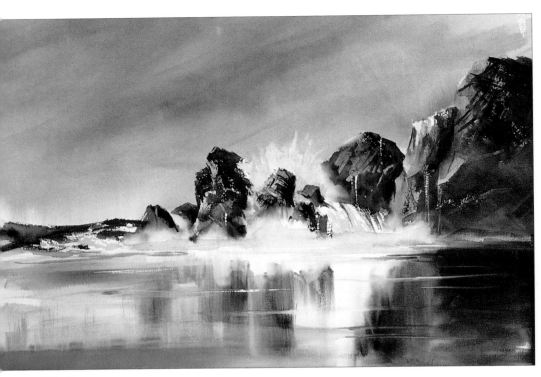

Night Storm
Size: 710 x 480mm (28 x 19in)

Waves crashing against the rocks provides the drama in this painting, and a dark sky is necessary to contrast the white spray. Winsor blue, together with permanent rose, ultramarine blue and cadmium scarlet were fed into this area to create a lively backcloth.

I used a clean damp sponge to drag paint out of the sky and rocks to create the spray.

The shallow water on the sandy beach in the foreground was produced by a thirsty brush pulling the dark shapes into the sand colour.

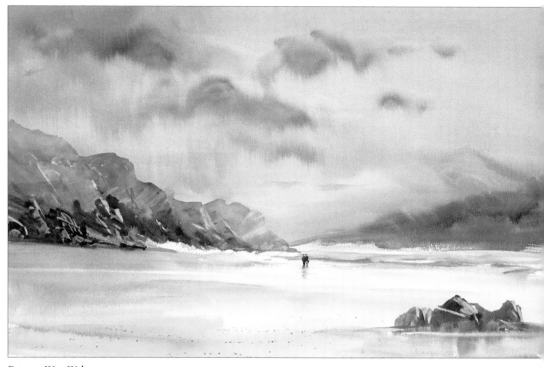

Estuary, West Wales
Size: 710 x 480mm (28 x 19in)

This moody sky was painted quickly, with cobalt blue applied on dampened paper. The clouds and the distant hills at the right-hand side were then added with a thirsty brush and a mixture of cobalt blue and cadmium scarlet .

When the sky was dry, I painted the hills at the left-hand side, then flicked a paper towel diagonally across their edges to break up the hard silhouette.

I used a scraper brush to pull out the light areas of the rocks on the beach.

Index

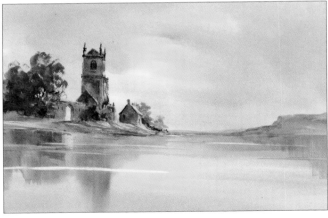

Church Reflections at Yerwol
Size: 470 x 305mm (18½ x 12in)

Aureolin, permanent rose and cobalt blue were mingled into a wet sky area using similar tonal values to those for Cardiff Docks on page 30. A thirsty brush was used to define the far headland while the sky was still wet. The church was painted in using the same colours, with touches of raw sienna and burnt umber for shape and form. The sea was painted to mirror the sky, then a thirsty brush was used to drag the colours of the church and foliage down into it to create the reflections.